Y0-AIM-585

The Pig Barn

A Memoir by

Marlon Davidson

Loonfeather Press
Bemidji, Minnesota

Copyright © 1997 by Marlon Davidson
All rights reserved. No part of this book may be
reproduced in any manner without the written consent
of the publisher, except in the case of brief excerpts in
critical reviews and articles.

Printed in the United States of America
First printing 1997
5 4 3 2 1

ISBN 0-926147-09-9

Loonfeather Press
P.O. Box 1212
Bemidji, MN 56619

Loonfeather Press is supported, in part, by a grant
provided by the Region 2 Arts Council through funding
from the Minnesota State Legislature.

This publication was made possible, in part, by a grant
provided from the Region 2 Arts Council through
funding from the McKnight Foundation.

Illustrations and cover photograph are from drawings
and photographs by the author, with computer imaging
by Micah Waalen

Cover design by Micah Waalen

Acknowledgments

Portions of these pieces were read as commentaries on KCRB, Minnesota Public Radio, Bemidji. I am indebted to Susan Carol Hauser, who made invaluable suggestions regarding the manuscript, to Micah Waalen for his assistance in preparation of the graphics, and to my editor, Betty Rossi.

This first one is for Don

Contents

Introduction	*1*
Sun Sign	*7*
The Pig Barn	*9*
Death Watch	*19*
Her Legacy	*21*
False Dreams	*31*
The Death of Cats	*33*
Silent Night	*41*
Moon Watch	*43*
Late Fall	*51*
Leafage	*53*
Other Islands	*63*
Change	*65*
Illustrations	*5, 17, 29, 39, 49, 61*

Introduction

I stood in the corner windows at midnight, looking at a dense and silent snow, the large flakes falling straight down like tiny white umbrellas against an inky blue-black background, dim trunks of bare poplars nearly invisible. We had turned off some Brahms and were ready to fill the fireplace and go to bed. But something held us, a conversation we had not yet had, one we needed but had put off. I turned and looked at my partner.

"We have to leave here, don't we?" he said.

I nodded. I knew.

When we had first moved to our grassy hill it was difficult to imagine that we'd ever want to leave such a place. We had come every summer when school was out and returned to St. Paul a week before workshop, a ten-week vacation in a place of beauty and peace. Our friends visited us, we worked hard "making improvements," but we had no problem taking the entire days off to walk in the woods, to go on long, extended ventures into the swamp, to swim and to pursue our art. I had a studio area in the cabin and my partner worked on sculpture and furniture; both activities continued at the lake. Our days were rich and full.

Then I burned out as a teacher and we needed to leave the Twin Cities where the stresses of life and the pace had increased. We decided to sell the city house and move to live year-round at the lake and begin a new life. We did all that and for several years we lived there and produced art, furniture and sculpture. We made periodic trips to the Twin Cities to sell and exhibit.

Our friends came in the summer but winters were long. They were certainly beautiful and cozy but also lonely and isolating. We missed the contact with other artists, intellectual enrichment, theatre, music. And although our long and intense partnership was untroubled by our isolation, we missed the activity of a social life. It was clear that we had to leave.

And so after a total of sixteen years we sold our grassy hill, the low shelter which had become a large, rambling house with no resemblance to that other simple, basic structure we'd found all those years ago. I have never been back. I don't plan to visit. What I have from that period is inside me and what has happened to that place has no meaning. Yes, two of my cats are buried there but they live in my memory.

Since the middle sixties I have kept a journal. Recently, reading the entries of that first summer at Hand Lake, it all came back—the smell of the building when we first walked in, the feel of the sun on our bodies as we put on a new roof, the incredible silences. I was inspired to write this memoir from those notes. *The Pig Barn* fell together naturally, the experiences of ten weeks in another life.

If I have learned anything from all this moving about, it is that what is most precious, most important, is often all around us. And that by imposing improvements we move away from bliss. I know it and think about it, but I continue to change my environment and to make improvements as though the urge is present in

my genes, this need I have to impact the spaces I encounter, to create environments that will fill some intangible void. There is a subtle distinction here between the changes that take place naturally, part of the great flow of life—changes that I want to allow, even to welcome—and changes that we impose on our environment out of this passion to improve things, although we cannot always explain to ourselves or to others exactly how these changes actually do improve anything. As in all abstractions there are gray areas. Sometimes it is difficult to know whether a particular change is the result of this latter fanaticism for manipulating environment, or the former, the natural flow of change that is constant and endless as a line of sandy beach that changes with every tide. Perhaps we need to pay attention to the subtle distinction, to ride the ebb and flow, to recognize the differences.

Sun Sign

This old brown grassy hill
Under my feet is the top,
The crown of the earth.
Here on this turning island
Waiting for a sign
The white dome is silent
But dense with expectation
Ready for God to speak
So sure of revelation.
It has been a long wait—
Hours, days, months, years—
Snow falling like feathers.
Rivers run and summers burn,
The leaves fall down slowly
And sink into the earth.
I search the heavens where
A long line of geese
Pierces the sun.

The Pig Barn

It was a pig barn, so they told us, a long, low, log building hugging the top of a grassy hill, abandoned for years, something vaguely Scandinavian about it, solid, serious, as though its builder had something permanent in mind and hadn't smiled often while constructing it. There were small, squarish windows, open to all weather, bordered by flapping, discolored plastic and, on the roof, black, torn tarpaper held down by long wood strips. On the north side, toward the lake, was a series of animal pens, all of aging wood gone silver gray in the weather. To me they suggested picture frames, weathered boards around a colorful landscape.

It was November, skiffs of snow in the air, the landscape colorless and drab. The summer grass was bending and brittle after repeated frosts, dead and discolored asters leaned over the lower rails of the wood fence. The trees near the lake were dark and bare, skeletal, their true forms revealed after a summer of hiding behind a covering of leaves. The lake had not yet frozen and lay in a huge, metallic, gray-blue flat surface to the distant shore where a band of smaller trees formed a horizontal brush stroke of very pale violet.

We walked through the dark interior pointing to a place that could be a kitchen, another a sleeping area, and suggested the priorities of work to make the space livable. We'd been looking for an escape from our city life for three years and something here spoke to us, some silent urge moved us to look at one another and nod; this was it. We drove back to the small town fifteen miles away and contacted the realtor, wrote the earnest money check and then made our way back to St. Paul to finish out the long, cold winter.

The following June, when school ended, we rented our city house to a graduate student, put our cat Barny in a cardboard box and packed up some kitchen supplies—tools, enough clothing for a summer—and drove off, like the Minnesota elite, joining that happy crowd who could use the holy phrase, "Up North!" Barny, his first experience with travel, yodeled all the way, sounding as if he were being subjected to torture, then suddenly becoming deadly silent, only to offer again a new and terrible, heart rending yowl. We tried to ignore him and rode on in optimism and eagerness, although we may have wondered, silently, if we might be making sounds like that ourselves before the summer was over.

We slept just one night in the car, slapping at mosquitoes and listening to a fine, soft rain on the roof. The cat had finally grown completely silent and exhausted from terror. Where he lay on the floor, freed of his cardboard prison, I could reassure him with a pat on the butt. Eventually, toward sunrise, I heard him begin to purr.

Morning brought a sunny, perfect day, windless, the grass soaking wet from the nighttime rain, and Barny took his first hesitant steps into it, daintily raising his paws from the moisture and looking at us with questions, "Is this okay? Where have you brought

me? How can I find my way back home?" Before we got involved in our first work, he disappeared into the grass, meowing his nervousness, responding to some instinctive feline call to adventure.

Priorities. Shovels. We dug a six-foot hole and built a crude outhouse using lumber that had been delivered the week before. We opened the log building and shoveled out the ancient pig dung, now reduced to an odorless, dark substance which we were sure would serve as the world's richest fertilizer when dug into our garden areas. We swept the interior, washed and scrubbed the excellent concrete floor, the inner walls, the wood ceiling blackened over the years by the unsanitary spottings of a million flies. By noon we were a filthy mess, long runners of grime streaking our arms and bare chests, and we went to the lake to bathe before a picnic lunch of sandwiches, cheese and fruit. We were just finishing some sweet golden pieces of cantaloupe when Barny came out of the grass with a field mouse drooping from his mouth, his eyes bright with the excitement of the hunt, his tail straight up in pride. He lunched too and then lay on his back in a sunbeam and had a bath, no more questions, just the ecstatic acceptance of the newness, the rightness of this experience, the beginning of a long series of summers full of delight for him, although he had to pay for them each year with the terror of the ride to and from the lake. The last years of his life, I am thankful to remember, were there, in his paradise, and there he is buried under a rock in his hunting field.

In the afternoon we put some huge sheets of black plastic over the inner walls, clear plastic over the small windows, and made a screendoor for the entryway. By evening, when we lit the candles and put together a simple dinner cooked on the hibachi, we were exhausted, unused to the combination of fresh air and physical

work, two sources of sleep inducement. We slept outside in our sleeping bags that second night, the cat attacking our wiggling toes in the dark, the sound of the wind and a thousand vocalizing frogs lulling us into a deep and satisfying sleep, Barny eventually wearing himself out too and curling up there at our feet, harmonizing with alto purrs the melody of the frogs.

In the next days we made a lot of improvements. We cut out huge hunks of the walls and installed large salvaged windows. We put in a small, freestanding fireplace and put a hand pump on the pipe in the yard. It drew cold, clean water on the tenth stroke, a great improvement to carrying water from the lake, although we were reticent to drink it until it was tested. It proved safe for drinking and made the best coffee I have ever tasted.

We lined the inner walls with light colored sawmill lumber with the blade marks still showing and making soft, shadowy circles in the grain, this over several inches of insulation. We put on a new roof, growing ever more tanned as we worked in the sun. We continued the cleaning needs and laundered that ceiling at least three times, finally realizing that it was solid, tongue-in-groove, narrow hardwood boards, a ceiling for a mansion, and in the evening when the sun came in it glowed gold, like the antique wood I had once seen in a church in Denmark. We had learned that the man who built the structure had raised prize hogs but really, it seemed a ceiling for thoroughbreds, and so, we decided, it had become. We put in some partitions, room dividers, no doors, everything open and light, and we could stand at one end of the interior and look to the opposite end and beyond, through the corner windows into the deep woods and to the hillside where there were balsam trees, and beyond that, to the west where the swamp began,

an area fully in bloom with trillium and bellworts. One of the reasons we had chosen this place was its proximity to swamp and all that implied—Minnesota orchids, the feathery branching of tamarack which is the noblest and most alluring of all bouquet fillers, spectacular and stunning when combined with Indian paint brush or daylilies.

We used the lake to bathe and to swim. The water was still cold in early June but it was spring-fed with the clearest of water and had a sandy bottom like the ocean, yellow spatterdock blooming on its surface and agates hiding among the pebbles and varied rocks on the shore.

We went to bed early and woke with the sun streaming in the east windows, refreshed, ready for another day of hard work. Whatever insomnia I had from the stresses of teaching left in the first week and I dreamed of golden fields of light, primeval forests and glens, the animals of Eden, friendly and unafraid, the lion lying in peace with the lamb, the world we desire and long for, as if it might once have existed and we are expected to find our way back to it.

We were soothed and touched by the long silences. The night sounds were mixed—the lonely calling of loons and unidentifiable cries, puzzling, troubling, raising the hair on our arms and causing sensations of pain and panic. Barny would rise up on the blanket and look at me with deeper, more penetrating questions than I had seen in the yard. He stayed in at night and all of his life lived on a human calendar. These night calls of distress, a small animal dying, were important to me intellectually, as an artist and as a human being. They compromised my peaceful dreams, adding darkness and shadows, expanding them, not into terror but to a more complex place where the lion might loom out of some darkness and roar. I

suppose I knew that nature is not always beautiful but it was a knowledge that lay easy on my soul. During that summer, living so closely to it, I learned just how bloodthirsty it really is. I realize now that nature is beautiful only when viewed from a distance, through the scrim of preconception and illusion. Look closely, and you may gasp and turn away. This is one of the reasons I find wildlife art so unsatisfying: it doesn't reveal the mysterious, complex reality of nature, that cry in the night. This genre of painting presents a natural world of perfection, as if Adam and Eve had never left the Garden. Perfect sunsets and the unblemished still-life just do not have the answer I am looking for. I do find it occasionally and when I do, I know it. Art has to include the knowledge of the dark side and it is a component I look for in all of the arts from poetry to music, from visual art to dance.

As I lay in my sleeping bag, night after night, I came to a place where I knew the sounds of the house, and if a mouse moved in the kitchen area, I heard it, and was content with its presence and felt no need to destroy it or to drive it away. More and more I wanted to live within the reality of nature and to change it as little as possible, despite my discomfort with the food chain and its implications. What we were doing to our grassy hill and its old wood shelter seemed like an intrusion and our actions made me uncomfortable. I wished that we could stop our mad pursuit of improvements and just let things be. But we are driven to change our environment, to make our surroundings fit our needs, even when we might live with nature in comfort without transforming it into a parking lot or a formal garden.

At times, when there was no wind and the frogs had exhausted themselves there would be total silence, dense, the sound of eternity and space. I lay in peace in my warm case and wondered if ever in my life I had

heard such perfect silence, and I had to hold myself in the real world by sheer force of will to prevent my slipping off, floating, escaping, entering this great silence alone, making a complete transition, never to come back to my familiar world and its responsibilities, to the world of money and bills, of food preparation, of keeping promises, even of human love and its commitments.

In August, about a week before packing up and driving back to the city, Barny suspicious and narrow-eyed at the packing of boxes, we had electricity put in and added a cook stove and refrigerator. That last night when I went to bed in the dark, I heard the motor of this looming convenience come on and hum at me against the silence of the night sky, against the distant whispering of the late summer wind, and I realized just how much we had lost. The intrusive, electrical sound pulled me back to a reality that was too ingrained in me to leave and I regretted the loss. I realized that it had been the happiest summer of my life and that it was gone. All I had was the memory of it and the knowledge that my modern, comfortable world possessed me too thoroughly to allow me to enter the peace and silence of that other place. I had borrowed a moment of it but now I had to give it up. I would go back there to that hill again and again, seeking it, but it was never the same.

Death Watch

Toward the end through that last day
She looked like a scrawny bald bird
In her cold nest of white sheets,
Eyes for seeing in the dark huge, staring
At me with wonder that she could have
Come to this bony lesson in anatomy,
And for two weeks mute, silent, dumb.
Could that terrible beak open again and
Speak my name or make a pitiful cawing?
I leaned in close and she struggled to speak.
"Why did God make the world?"
Looking fearful at what I might answer
And I had none.
But inspiration came,
"Because she was lonely."
She sighed and relaxed into her nest.
There might have been a smile
But who could tell with that face
And those talons.
At the cemetery a woman clutching a hard
Black purse said, "She was a saint,
Truly a saint," and several people
Nodded agreement.
But we knew something, she and I,
We had our secret.

Her Legacy

During that first summer we had at Hand Lake I thought a great deal about my grandmother, a country woman who had an impact on me when I was a child and lived beside her on a remote lake in the north country. When my parents took me away to a city I continued a relationship with her that lasted until her death at the age of ninety-six.

I was reminded of her by sounds, smells and events during that first summer at the pig barn: the sound of the screen door slamming shut, the bang-bang-bang of the fly swatter, the lilac bush and its burden of fragrant blooms, the pumping of water from the well, the low prickly clump of white roses and their distinctive smell. I had thought these images and events might be lost in the dim reaches of a child's forgetting but they were there, only needing the experience itself, the feel of the pump handle, the fragrance of lilacs, to bring her back.

She rests in peace in a cemetery in a northern county. I try to make a trip there in the spring, to visit the graves of aunts and uncles, a young cousin, and to pick up the accumulation of winter and rake away the dead leaves. I pick up the two terra cotta pots with their

corpses of geranium which I fill again for Memorial Day, following now, in my late middle years, this pattern of my culture far more than I did when I was younger and death was a vague abstraction in some distant future.

It is my grandmother I think of most when I view these orderly graves, her final bed beside my grandfather, the tombstone with its assertive and proud message, "Married Seventy-five Years," her own epitaph for them both. It seems to me now that part of the reason they achieved that impressive diamond jubilee of anniversaries was her own fierce determination, reminding my complacent grandfather that he must not die before they had achieved it. It was the proudest accomplishment of her long life, even more important in her mind, I believe, than the successful rearing of four children. When the television people came to document this amazing event, to ask the usual mundane questions, it was she who told them where to put the tripod, who filled their tapes with commentary beyond what they wanted certainly, giving them an unsolicited religious sermon and finally, critically reviewing what they chose to telecast, lamenting loudly that, "They cut out the best part!" while my fat and happy grandfather sat back quietly and smiled his amused and tolerant smile, letting her do the talking and complaining, as he always had.

There is something of this woman in me. It may have to do with genetics but perhaps I was influenced by her during those summer afternoons when she would take me to the woods, naming the flowers, gathering wild mushrooms, yes, preaching her old-fashioned, homespun brand of fundamentalism, rejected by me for years, spurned as corny, anti-intellectual, and self-righteous. Eventually I came to my senses and realized that I didn't have to agree with her to continue loving her and learning from her . . . just as she may have decided about me.

It would be comforting to find in my memory a way in which her religion graced her life, because much of its influence did not. Her beliefs made her critical, judgmental and prudish; they limited her. I doubt too that it was religion's influence which made her the champion of the underdog, the savior of little children; I'm sure it was something more basic. I have seen her zoom across a supermarket aisle to caution a young mother that she had just pulled too hard on her son's arm, or point out to another, probably frazzled young woman, "That baby wants to be picked up!" or, in one amazing case, exclaiming to a beefy, red-faced man that if he didn't stop swatting his little boy, she would call the police and have him hauled away and locked up. To her, children were always right and what they needed now and forever was love, more love, and if they got into trouble, it was the parents who were at fault, not loving enough, not attentive and caring enough, too distracted by their selfish and indulgent lives. She often told me that she had never struck one of her children. "Never had to."

Due to a variety of complicated events, she ended up spending the last twenty-five years of her life in a community of fifteen thousand people, to her a metropolis, a university town where several of her grandchildren earned college degrees. She had a pattern of loyalty to whatever became dear to her and this community did. You did not say a critical word about it in her presence, or about anything that she cared about. I think nowadays, we'd say that she had "attitude." She could certainly assert herself without any training in that area. She might have taught such a class but would have been too impatient and abrasive for her students; there would have been a great many dropouts. She was a person who could win arguments by sheer force of personality: people were often silenced by intimidation, not a pleasant sight, but to me, when I was younger, it

gave her a kind of grandeur and I stood in awe, hoping that one day I could silence my enemies like that.

She retained her country ways to the end of her life and her speech was full of oddities and peculiar usages, embarrassing at times, appreciated most later, after I'd matured and read Eudora Welty and Faulkner. A puzzle was a conundrum. Paradise, heaven, where she was sure we would all eventually gather, was "The Land of Goshen," and it was many years before I discovered the source of that lovely phrase. She would have told you that the reference was from the Biblical book of Genesis but I doubt that she would have said that her use of it was metaphorical and would have impatiently tapped her foot at anyone using such fancy talk.

At our earthly family reunions, we always sang our grace before meals, the same song over and over, through the years, until she was gone and we found that it was impossible to sing it, our throats closing at the many absences: *"Jesus has the table spread, where the saints of God are fed, He invites His chosen people, come and dine. Come and dine, the Master calls us, come and dine. We make feast at Jesus' table all the time. He fed the multitude, turned the water into wine, to the hungry calleth now, come and dine."*

I can hear her still, that great soprano voice rising above all of the rest of us like the last scene of a great opera. She could have sung Wagner if she'd lived in some city and been trained with a fine teacher. But had she studied and gone to sing *The Ring* in the leading opera houses of the world, I might not be here. I am glad that the world of opera was deprived of this great voice so that I might have these memories. There are other Brunhildes but only one such grandmother and I refuse to give her up, even in imagination, to the stage.

There are many ways to give her singularity. She refused to say anything bad about the weather, a precious lesson to a child growing up in punishing and unpredictable Minnesota. Every day was a gift from God and beautiful. She was the perfect foil for my grandfather who never said anything good about the weather, or about anything else, that I can remember. If it was forty below, my grandmother would remind us all, soberly and with total conviction, "We have to have this cold to kill all the summer germs. Why d'ya think they've got all those terrible fevers and diseases in the south?" Statements of this kind were in capital letters, the final word on the subject, and if it was framed as a question, it was for effect and you tread on dangerous ground to question. Disagreement was unthinkable.

She had an undying optimism. No matter how bad things got, she would find a source of light, of hope, the promise of a way out, characteristics which were important when she lost her only son, a man of thirty-nine with children to raise and then when she lost her young grandson, twenty-one years old and full of promise, a sweet-natured boy, to a car accident. I don't remember that she cried either time. She seemed to put on some inner armor, some steely strength of will to get through the worst of it before going on with the rest of her life. People turned to her for courage although she wasn't one to hold out a hand. She expected people to be made out of the same impervious material as she. The message was, "Yes, it's bad, but buck up. We have work to do and a life to live."

I feel fortunate when I consider her characteristics, characteristics which I too possess. Without any doubt I will need to remember what she said to me, at ninety-two, when I asked her if she could eat the raw onions I was cutting up for a salad, "I can eat anything."

Or the attitude that would make her say, when showing me the new eye medicine that her physician had prescribed shortly after her ninety-fifth birthday, "I have to take this for the rest of my life!" as if that might be a very long time.

I know that I'm a lot like her. Like her I sometimes have a problem keeping my mouth shut. Like her I am too ready to speak and often find myself embroiled in argument. Yet, in spite of all this, I'm glad that I am like her. Maybe speaking out isn't such a bad thing. As a matter of fact, she gave me a precious legacy. She gave me attitude.

False Dreams

A hot circle of weight low on the bed
Waking from some cold depth in the silent room,
A sleeping poundage of trust and love,
A heavy bag of cat,
His heaviness like human touch
As familiar as skin or nakedness.
Also there is the weight of you unconscious,
The same back for these years, the same
Contour of flesh heavier than cat
Tipping closer, sleeping again,
These familiar weights close.
If one were gone there would be a
Rush of terror,
Reaching out for the missing weight
To cold sheets, an echo of someone
Closing a door far off in the hall,
Cat lost in traffic or lapping poison,
You watching football and drinking
Bottled beer.
So crazy the nights
So false these waking dreams

The Death of Cats

We are told as children that cats have nine lives, and we learn the song, "The Cat Came Back." Both are examples of American folk lore that carry some truth, some inner core of accuracy, as do most folk tales. But personally, I suspect that these familiar lines also help assuage the collective conscience of our tribe who, in many ways, are cruel and brutal to cats and to all animals. Many people loathe cats. When we look at the long history of the relationship between the human race and domestic cats, we have little reason for pride. Cats do benefit from humans, fluffy on her red cushion, but I suspect that they do more suffering than they do benefiting from our influence. There is an irony implicit here too, because by loving them, protecting them, by giving them shelter, we make it possible for cats to proliferate and thus more are produced than can be saved and given homes. Hundreds of thousand of them live brief, miserable lives. They are abandoned, dropped off in the country, starved, mistreated and murdered. Any animal shelter can give an accounting of the sad state of many of the animals that arrive at their doors. The alleyways of any large city witness the pathetic civilizations of cats who live

by their wits, often hungry, raising their family in garbage cans and eating, when they can find anything, garbage.

It would be easy to romanticize the human relationship with cats, even the characteristics of these physically beautiful creatures. But any cat owner who is observant will admit to the whole list of negatives associated with cat behavior—their lack of compassion, their willingness to kill and torture for fun, their indiscriminate and constant hunting patterns, the fact that they kill hundreds of thousands of song birds annually. Intellectually I know that in the great scheme of things a song bird is no more precious than a field mouse; still it hurts to see the sunny, yellow feathers of a canary go flying into the wind, my cat Pedro with the bird in his mouth. I have often thought, in my cynical moments, that when a monster eagle comes sweeping in and hauls Pedro away to devour in his nest and to feed to his young, it would only be biological and natural justice. Yet I would fight off that eagle, climb any tree to save my cats because I am a cat lover.

I have an uncle who loves guns. It is a love affair that I have never understood because I have an aversion to guns, although at times, out of necessity, I have used guns. Since this uncle of mine realizes that I don't particularly like guns, he is crazed to put one in my hands. I have to be on my guard when I am around him or he will thrust one into my arms, his excited eyes aglitter, before I know what I'm being offered. He has a collection to outfit an army. When I ask why he would need a demonic looking automatic, he says ambiguously, "You never know." He has a farm and the old barn is infested with cats, all wild, terrified of people, due, no doubt to my uncle's behavior toward them. Periodically, so he tells me, he takes down one of the big guns and kills off about half of the cats. The great hunter. "You

gotta keep the population down ya know," he says repeatedly, watching closely for my reaction. He knows that I love cats.

Barny, a cat who came into our lives while we were living in St. Paul, was a city cat who did go outside, but hardly farther than the fenced-in back yard and some excursions in the jungle along the alley where he had a midden, and, at some distance, a sleeping area among the peony bushes. When we moved to the lake, he quickly became a country cat, a skilled hunter who extended his real world into the woods along the pathway to the lake and to the lakeshore beyond, indeed, to regions beyond my knowledge where he would disappear for hours on end. Still, he continued his human pattern of sleeping in at night on the foot of the bed, as all of our cats have done. I was uncomfortable with the killing but I tried to accept it and eventually even gave up trying to teach him why he could kill one creature and not another. I would find his offerings lined up by the front door, a soft little brown mouse, a fat vole, a brown bird which seemed to be sleeping, on one occasion a bat with bloody fangs. He lived to be fifteen and we buried him in a grassy field where he had pounced upon a thousand mice.

We were catless for two years and did some traveling. Then a friend who was moving to New Mexico brought two young cats, siblings, which we named Fanny and Alexander for a film we love. Alexander died at a very young age of a heart attack brought on by terror after an encounter with a feral cat. Since he was a great pacifist, we understood. He lies beside Barny in that field, both animals resting in fine wood boxes with cloth lining. Fanny, Alexander's sister, is still with us and about two years ago we acquired Pedro, who coincidentally has the same markings as she but is large, gangly, big-footed and sweet. At least he is sweet

to us. Fanny thinks otherwise and hisses in his face at the least provocation.

Fanny is thirteen now and will not live many more years. For one thing, she is overweight, a characteristic we share, she and I. It is difficult to estimate Pedro's age, for he came to the door starving and was an adult cat when he moved in. He seemed young. No doubt he'll be with us for many years. Yet, if I live on into my dotage, I will see these animals perish, and any others I might acquire. It feels like a family loss when they go. One of the important lessons of life is that we have to give love a chance and that if we are unwilling to make that leap, we give up the love that is given in return. Yet although we are always aware of loss, of death, of separation, abandonment, it is worth the chance we take. I will always have cats. When these animals are gone, I will find some others.

Cats lose their lives on country and city roads and streets. I have had numerous close calls and witnessed at least one death from a window of our city house, the death of a big gray tom I knew well from his visits to our yard and to our back porch, back in pre-Barny days, before I knew that I needed cats. I had no idea who owned him but I called him Gus. He liked the name and would sit and stare at me with studied calm, though I was never allowed to touch.

He was mangled under the speeding wheels of a red Buick and the insensitive driver didn't even stop. I ran to find him just as he was breathing his last, a gasp, a quiver of flesh and he was gone. I got a cardboard box and shovelled him into it. I carried him to our back yard and dug a hole against the back fence where I was just putting in a peony bed. When the plants bloomed in splendor some years later, I thought of Gus and his fertilizing contribution to the flower bed; in fact, for

years we called the crimson blossoms of one plant "Gus's Blood" and dug the plant and took it with us when we left, unable to leave what had become a shrine.

When animals are in pain, we set them free. It is painful but who would allow a beloved pet to lie in pain for all the days it takes to die? Is there a lesson for us in this act of kindness? When our cat Barny was in his last days, clearly suffering, I called a vet and asked her to come out to the house and give him the lethal dose. I explained he was terrified of the car and I refused to have him go to his death in terror. She said, "Oh, we don't make house calls. You'll have to bring him in." I had been led astray by the sensibilities and gentility of *All Creatures Great and Small* and had forgotten that the world has changed.

It seems to me that we cat lovers need them far more than they need us. They managed quite well on the earth before they condescended to creep in, to be our pets. I imagine them watching us from the shadows, their eyes glowing with the reflection of our early fires, a scrubby bunch of us homo sapiens in front of a cave. As they peered out of the dark, they wondered how they might make use of us. Someone tossed out a hunk of venison and suddenly they knew. When the first inquisitive and courageous cat moved in from the shadows, it could feel the warmth of the fire. Then the fingers of a lonely child in its fur.

They have gained something by living with us, but we have gained the most.

Silent Night

Under a November sky my brain feels
Like an atom, so small and light.
Presumptious as always, I silently
Hurl questions into the dark, into history,
For all these lights are old, some dead and out,
Their billion candles cold, their memories of
Planets teeming with life and light, snuffed,
Obliterated, forgotten.
Some gleam steady and calm, others quivering,
Glittering, the two kinds of light suggesting something
Of my questions, my introspection, my loneliness.
The calm eternal ones, the others blinking,
Dying out, leaving a residue of darkness,
Black holes, burnt out and forgotten.
The sky is familiar but I remain confused
Considering my tangle of genes, gazing
At the source of my species, in star and stuff,
Quasars, gallactic dust, yet ignorant and
Yearning, a pull toward the giant spiral,
Our home, this galaxy and
Its numerous worlds,
The moon and its ambiguous wanderings.
I've waited a long time but
No voice speaks, no signs and wonders.
The heavens are as maddeningly silent as
Always for those who go out under a star.

Moon Watch

The path to the east of our grassy hill led down a steep embankment and into the swamp. We wore sneakers when we went into the dark and cool alley we'd created between tamaracks and spruce. Even in late July or August the bog water, which came up to our ankles, was icy cold, making our feet ache. Out of the cushiony base of soft sphagnum moss and frigid water grew the exotic orchids and odd botany of the swamp, the carnivorous pitcher plant with its phallic leaves, their deep red vaginal throats, the queen lady's slipper orchid, the exquisite rose pegonia growing on graceful stems in sunny openings where small swamp ponds had mossed over and made verdant trampolines. Our feet bouncing against the underwater, we two spring along like clowns. I would often see large fat garter snakes lying in the sun, swollen and sluggish after summer gluttony, a feast of frogs, part of the terrible food chain of this planet, an aspect of nature's design which still leaves me chilled and puzzled, unable to understand, to assent or to accept an arrangement which seems designed by a demon rather than a beneficent deity. I cannot help but consider all of the small, peaceable vegetarian animals that have been

terrorized, chased down, swallowed or torn to pieces for millennia, millions of them. Who made this place and why? It seems to me to be a great barrier to religious faith and I am still struggling with it.

Beyond the swamp the land rises again, a bank of fallen trees, bare earth, grasses, rock and brush, this rise pushed up by some ancient glacier when, time out of mind, the gullies of lakes and the mounds of hills were made, like the waves and troughs of a great sea, here turned verdant with growth, grassy hill after hill, and lake after lake.

We often crossed the swamp at dusk, like two cave men on a quest, to climb to a place we called "Moon Watch." Here facing east our vantage was unobscured by large trees and we could watch the rising of the full moons of summer and fall, the circle seeming larger each month and sometimes more intense in color. I like the Native names better than our own and so we named them, whispering the names into the air, "Strawberry Moon," "Wolf Moon," "Full Moon of the Fall Leaves." Sometimes we would invent our own names for the moon and keep them a secret: "Song of the Loon Moon," or "St Paul Moon" because it blossomed just before our return to the city.

Once we took friends to witness the full moon rise and made them trudge with us through the swamp and up the hill to stand on our private viewing ground, a great gift we thought. We stood as usual, in reverential silence to see the pale yellow rim appear above the grasses of the vast bog. For a long time nobody spoke. It was as if these city dwellers had not realized that the moon did this great appearing scene, that it rose in such majesty, silent and huge in the blue dark. They may have thought that we, their hosts, were working some sort of moon magic. Earlier, back in the Pig Barn, someone had spoken of the special "feel" of this place,

the peace and quiet of it and maybe they were convinced that we possessed unnatural powers and were making all of this happen to impress, to shock. At some point someone said, I forget who, "What's happening to the moon?"

It was clear to us all that something was happening. A part of one side of it was diminished; as we stood silent and puzzled, even frightened, it changed even more. Finally, when the change was profound, nearly half of the surface of the circle darkened, I said, "An eclipse."

Someone said, "A what?"

"An eclipse of the moon. The earth's shadow."

"My God."

We hadn't looked at a paper in days nor read the astronomical predictions for weeks. And our friends didn't follow such arcane material and believed that eclipses were a subject for science fiction. Or if they did happen, it had to be in China a long time ago. To them, there was something sinister about it and they associated the fearful nature of what was happening with us; we had led them into the falling dark and an unfamiliar woods where something was happening that might let fall a curse. Our friends held on to each other and moved a little away from us, giving us odd, mistrustful glances over their shoulders as they turned back to the slowly disappearing moon.

When it finally went all dark, with the ghostly halo glowing a pale phosphorescent green, I heard the man say, "How the hell are we going to get back through the swamp in this dark?" For it had grown fearsomely dark and the path and the entrance to the swamp were obscured by shadow and dimness with the moon's exit. We stood in two clutches in the growing dark and I could hear the breathing of three people and feel my own. It seemed strangely colder, a chill settling over the land.

Behind us at the edge of the swamp, as if to comment on the sudden dark and chill, some insane bird made a low cackle, a crazy laugh, a bizarre human sound, and one of our friends said, "What the hell was that?"

I said, "Just a night bird. It's nothing. When the moon comes back, it'll be light enough to see." I wasn't really bothered by the bird sound, nor by the dark, but something of my friends' discomfort had crept into us, and I think that we stood closer and perhaps touched in the darkness, still held by the black circle in the sky with its peculiar ghostly edge, the dark center of a great eye.

"Will it come back?" I heard the woman say.

"Yes," I replied out of faith and trust, with no other justification for my certainty. If the dark circle never changed and we stood in this place for an hour, waiting, then I would truly be frightened.

"When?"

"Soon. Really soon. Watch the edge, the first glow to break through like a sunrise."

It took a long time. There was a burst of light, like dawn, a great streak of green into the black of the heavens where suddenly we were aware of stars. There was a palpable sense of relief, and after a while our friends went over and sat on a big log. They seemed worn down a little by fear, by stress, this primitive experience, something harking back to earlier times, perhaps setting the harp of their genes singing in their bodies, some melody faintly remembered from thousands of years earlier, our forebears watching just such an event with less certainty of its ultimate conclusion.

It was difficult going back. I am sure that our friends cursed us in the dark as we waded in cold water, the stinging points of pine branches slapping at us as we passed, our feet growing paralyzed with cold, that

mad, laughing bird following somewhere just behind us, repeating its crazy cackling, as if it knew we were out of place, intruders, and also, knew that someone was afraid. Still, in remembering that event, it seems odd to me to consider that our friends never forgot it, remember it with intense fondness and have learned more about the moon than I'll ever know, becoming, in less than a year, authoritative and highly knowledgeable regarding all aspects of the heavens. They brag about the event to the astronomically ignorant and shame them into learning about the moon, its phases and display. They have read omnivorously in the area of astronomy and know about penumbras and apogees, the moon's crazy patterns of rising and setting and they look with superior disdain at people who talk about astrology, that pseudo-science. It all began on a hillside near our grassy hill with the two of them holding onto each other in fear. But that is not what they remember. And it is not what I remember either really. I remember the repeated times that my partner and I stood in the dark and watched the full moon rise, our cat Barny on my shoulder, as interested in the moon as we.

 We lost much when we left the Pig Barn. We lost our "Moon Watch." I still go out into the dark and watch the full moon rise and I raise my arms straight up like an Eskimo and greet it. I sometimes whisper the names I know or others, invented ones, names to suit the color or the season But it's not the same. The passage through the swamp, the climb through the rocks and logs to our Moon Watch was a time warp and it took us out of the Twentieth Century. I might have gone there and climbed the hill to watch in animal skins, in fur and in leather, or even naked, but if I had, I might never have come back.

Late Fall

Migrating birds in the shriveled grapes
Whistling cedar waxwings stripping
The mountain ash berries and posing
The hard fall sky gray and spitting
Ice pellets at the leaning grass
A hawk crash-diving his sorrows
Against the far leafless trees
The bare honest branches the tossing
Leaves and cutting wind the lake
Cobalt and flat lilies all drowned
The fine shape of a deer's skull
Leaning against a blackened pine stump
The long thin white vapor trail
Of a jet gleaming toward the low sun
A distant gunshot a woods away
The garden wreckage
My worn out summer gloves
A rusting shovel.

Leafage

The adults I lived with as I was growing up tended to see things in black and white, right or wrong, with nothing in between. They had a way of placing everything, (even people), into small groupings at either end of the scale of morality and approval. This oversimplification influenced my early sense of values. I thought for a long time that people were either good or bad, Christians or sinners, and that all the events and experiences of my life could be put into the simple categories of wonderful or terrible. I still have to work hard to keep from making quick and judgmental decisions about people, about their behavior. What made me begin to change my perspective was the discovery that, although I was supposed to be one of the good people, I knew that I was not. No matter how often I went trotting off to church, or how badly I wanted to be good, there was that in me, I knew very well, which was bad. Although I came to realize that the adults who had acted out their roles as saints were as flawed as I, for many years they had me fooled. When I discovered their hypocrisy I was angry and began a series of rejections which took many years to end. I might never have really gotten over it if I had not had the

opportunity, in later years, to point out to these adults what I had discovered about them. Some had already made the discovery themselves, and others never did. They are still convinced that they are perfect.

One of my mentors often referred to events, acts, experiences, as "good for the soul" or "very unhealthy for the soul." He too had a scale of morality with little gray in it and his influence delayed my progress toward a realization that nothing, no event, no work of art, vocation, avocation, no personal act is thoroughly good or bad. Indeed, at this point in my life I feel that the ideas of good and bad are true only from some point of reference. Like the difference between pornography and erotica, what is ugly and repugnant to one person may be another's fine art. There may be some images that fit into the area of pornography for just about everyone, but for me the most obscene photographs and images are those which are brutal and violent. I would rather watch two people making love than hurting or killing one another.

A few experiences and actions seem to exist in a plane of wholesome, pure goodness that sets them aside as almost totally good for the soul. One of these is gardening. You could say, I suppose, that when the first killer frost comes and destroys the nasturtium bed, that is a negative. But at least when it comes to growing vegetables and flowers, nature seems to be well-designed and we can look at it closely without fear of being shocked or horrified. It may simply be that I am not looking through a magnifying glass. But working in the soil makes me feel good. I feel a part of it. I understand Wordsworth's phrase, "Rolled round in earth's diurnal course with rocks and stones and trees," because I do take part, I am a part of that great movement, the birth of flowers, their growth and inevitable death so that another spring may come. Being

rolled around in the movement of the seasons, sometimes feeling the rolling of the earth as it turns ever eastward, toward the sun, and tips away from it, making winter, is one of the great joys of existence. The closer I get to it, the closer I want to get. When I do get down into it, bowing over the ground, a kind of act of humility, I am reminded that to make food, some energy and effort must be made, and I feel good, healthier in mind and body.

 I had done little gardening before we moved to the lake, when we devoted a summer to making a pig barn into a shelter, to live close to nature. I remember gardens of my childhood, the vast fields of corn where I played hide and seek with my cousin. I had no idea that this action, this activity, would bring intense happiness to me in the future, and as a child I probably walked away from the hoe and rake, more interested in any escape from work. I didn't understand. It took some kind of maturity, some new perspective to bring me to gardening. When I put my hands in it, a new world opened and I thrilled to all parts of it, the planting of the seed, the verdant leafage that came in summer, and the harvest.

 When we went to the lake I started a garden right away. It was insanely difficult. I dug up the grass-impacted soil by hand with a shovel. It was necessary to stomp with force on the shovel to get it through the bound roots of many summers. I would cut a kind of square, freeing all sides of the mass, put the shovel aside and lean over, grasping the square of roots and soil, then shake it like a mean dog would shake a squirming animal. The earth would fall away onto the ground. I would take those roots and dead grass and toss them into the wheelbarrow for later use as fill in low areas of the yard. This was maddeningly slow work and it gave me painful blisters within a couple of hours. I could

only stand to work at this for about two hours at a time and then my back would spasm in pain. But I was young and recovery was fast and the work made me sleep well. I woke refreshed, rarely feeling any pain the next day, and the memory of that overnight recovery makes me realize how my body is wearing out. But then hard work only improved my well-being. After a week of this, I had a twelve by twenty foot garden, black rich dirt fertilized by those generations of hogs, a striking green border of new spring grass. It had been hoed to a soft mass and the small stones and sticks had been raked away. It had the beauty of something gained with great effort and it made a beautiful pattern, like a work of art, like a painting. I hated to touch it. Yet it also reminded me of a grave. A very large grave. A grave for an elephant. I do this all the time. I see pictures in clouds and in all surfaces, water, earth, stone, wood. I am a visual person and believe that I learned to read because I could make a picture of the written word in my head and a picture of what it said. I make pictures out of everything. In any case, the new garden looked like a painting and it looked like a grave for an elephant.

We put in seed. We continued our metaphor of a work of art, a big painting, and we put the seeds in crazy patterns, no straight and narrow for us. We made squares, circles, large Xs. We planted vegetables and around the edge, flowers: nasturtiums, marigolds, corn flowers. But we had a great many seed packets left. We needed more garden space. So for another two weeks we worked preparing more garden. My hands were hardening. We transplanted wild shrubs into the yard, leatherwood, sumac, high bush cranberry.

We transplanted trees by the dozens. And all of this was in addition to the work on the building itself.

I can still remember some two weeks later when the first green shoots came up. I would walk out there

in the morning with a cup of coffee and stare at the ground. Here was a tiny green shoot, a whole line of them, radishes. Small as they were, minuscule, there was something there of strength and passion. The little seed had pushed the soil aside and was reaching up with authority as if nothing could stop it, as if it was in desperate need of the warming sun, an escape from the dark cold of the soil. I had read of seeds splitting rocks asunder and now I believed it. And what was important was that I had planted them.

As the days passed the crazy patterns we had planted turned green, a verdant hieroglyphic to rival the sand paintings of the Southwest Indians. And it no longer looked like a grave. The gardens looked more like oddly-shaped, green drawings made by space men. Barny, with a look of determination began a demented digging as if he planned on visiting China. But he quickly stopped and used the garden for a toilet, the largest sandbox of his life where he would never need to turn away in disgust as he had often done inside, no matter how frequently his box was cleaned.

Since that time, since that first garden at Hand Lake, when we prepared the pig barn for shelter, I have never missed a summer of gardening. My expertise and my interests have multiplied, evolved and changed. I now grow about half flowers, half vegetables. We have an agreement, my partner and I, that we will never miss a spring of planting trees, maybe only a few, but always every spring, young trees that will eventually be shelter for deer and may even reach the majestic size of the hundred-year old white pines that surround our present home. I won't be around but it is comforting to think of the people who might live under them, of the shelter and beauty they will bring to the earth when we are both gone to another larger project. We will be moving through another plane and finding another sort of

leafage, another verdance. I expect gardens. My head is full of reasons why I expect gardens. "And God planted a garden Eastward in Eden," and the many references to gardens in the religious writings of all people.

 Sometimes when I am out there walking on a spring morning, looking for the first radish to push up, I almost think that I have it all figured out. Why nothing here is clear, why we humans are so full of good and bad, the world so full of trouble. The sun rises over the hills in the east and the world seems beneficent and safe. But when I turn away from the first garden leafage, I hear the eagle scream over the lake just as it dives to grasp a fish in its talons. And the questions remain. Still, there is the garden and I go there for comfort and inspiration. It is the place I feel the closest to the elusive answers.

Other Islands

Distant ragged shoreline
Lost in unfamiliar waters,
The hillside a tangled thicket,
Thorny vines and skeletal saplings,
Denser forest higher up to tree line,
Possible mountain peaks
But lost in lowering sky.
Dark towers of pine
Their tops in mist,
The nose of the canoe
Breaking into rising whitecaps,
Faces sprayed with froth,
Breath burning in our chests.
As dark falls rocky islands
On either side one after another
Drawing us, pulling at our need
To land the bedrolls and body heat,
Naked touch and darkness,
Some warm human harbor.
But still we move on to other islands,
Into strange waters,
A great wall of boiling cloud.
We pull harder and enter it.

Change

We live in an ocean of change whether we resist with the steadfastness of a rock or give in to it and ride in its welcome currents to some new shore. When we left our grassy hill and the large house, part of which had once been a simple shelter, a pig barn, I ruminated on change. I knew that change was constant, sometimes gradual like the aging process, sometimes sudden, like the loss of a person we love. I wondered if we were forcing a change that would stir and trouble the waters of our pacific life. But as with other changes I've had in my life when I've allowed a kind of momentum to carry me, I ceased questioning and said yes to change.

In some areas it's difficult. Humans resist change. We are creatures given to patterns and habits. We resist with every method we can imagine or invent the inexorable movement of time and its insults. Who, besides the young, has not rejected some physical manifestation of age, denied it only to realize its presence and permanence? We quickly claim territory and hold on to it. We will sit in the same chair in the faculty room until any move to another chair makes nearly everyone uncomfortable. I have a friend who has

repeatedly said to me, "I am apposed to change!" in a voice of lofty announcement, a phrase to take its place alongside the laws of Moses. It is an attitude which could contribute to a lifetime of frustration. Why do we so resist a reality that pervades all that we do? We join weight watchers. We have plastic surgery. We purchase fifty million dollars worth of hair dye. And yet we long for something new under the sun, for adventure, for variety. What a bundle of contradictions we are. It is this complex and contrary nature of us humans that makes us claim to admire and value the wisdom of the elderly and yet to do everything under the sun to keep from becoming one of them. While we scan the magazines and catalogs for wrinkle cream and hair restorer, the persistent finger of change is writing its message on our faces even as we stare aghast at the vision in the mirror. This is not the face I am supposed to have. Where did it go and who drew these unattractive lines beside my mouth and made these brown spots on my once clear and unmarked brow?

Long ago I decided to give it up and let go. I am ready to give in to change, to ride the current instead of fighting it. I believe that change is taking us someplace and that it has its reasons. Ultimately we may reach a golden shore. There are promising signs. Consider the turning of the leaves, the sudden whitening of the world with the purity of snow, the joyous bursts of spring, the return of the birds, the emergence of the swallowtail from its prison cocoon. Resist no more.

When we left our grassy hill at Hand Lake and the large, comfortable, rambling house that it had become, I knew there was something waiting, something new and important. Behind that Eden was a new morning. I allowed the current of change to take me, to carry me to a new island. I know there will be others.

Marlon Davidson is a lifelong Minnesotan. He was educated at Bemidji State University, the University of Minnesota and the Minneapolis School of Art (MCAD). He has been a classroom art teacher, a commercial artist, an arts administrator, a university teacher, a free-lance writer and the owner of a bed and breakfast.

He is a published poet whose short story, "Thinking of Samson," appeared in the *James White Review;* and a recent essay, "Where I Ought to Be," has been included in *North Writers II* (University of Minnesota Press, 1997). His visual art work is in public and private collections.

Davidson lives in the Bemidji area with his life partner where he teaches, writes and produces visual art.